GORDON PARKS:

whispers of intimate things

GORDON PARKS:

Introduction: Philip B. Kunhardt, Jr.

whispers of intimate things

BY GORDON PARKS

A STUDIO BOOK · THE VIKING PRESS · NEW YORK

To Vivian Campbell

COPYRIGHT © 1971 BY GORDON PARKS
ALL RIGHTS RESERVED
FIRST PUBLISHED IN 1971 BY THE VIKING PRESS, INC.
625 MADISON AVENUE, NEW YORK, N.Y. 10022
PUBLISHED SIMULTANEOUSLY IN CANADA BY
THE MACMILLAN COMPANY OF CANADA LIMITED
SBN 670–34667–5
LIBRARY OF CONGRESS CATALOG CARD NUMBER: 75–139273

COMPOSITION BY WESTCOTT & THOMSON, INC.
PRINTED IN THE U.S.A. BY NEFF LITHOGRAPHING CO., INC.
BOUND BY MONTAUK BOOK MANUFACTURING CO., INC.

INTRODUCTION

How to switch worlds?

To block out the hustling, marvelous, miserable, marketplace, impossible, close-at-hand problems of his everyday work life—the making of magazines and movies, of stories and pictures, of novels and music; the guests, the questions, the noise, the people.

How does Gordon Parks switch off all that and switch into the world of the poet?

An apartment in New York City. Four large windows gazing over the East River in a panel. To him the water seems to wrinkle in the early-evening light. The bridges cross the river like etchings. The place, those two rooms, should be good for writing. But they are also a stopping place for many people—ins and outs, comings and goings. He mixes, flourishes, relishes, stars—but in the next moment he stands apart from the crowded noise, away from the water window, looking out to the west onto the nothing-dark street, staring, thinking, suddenly a stranger to his friends.

When the people are gone and he is alone, the way he switches worlds is through music. Not his own, although Gordon Parks is a fine composer and lyricist in his own right. It may be Bach or Brahms or Prokofiev or Debussy, or it might be Rachmaninoff or Sam Barber or Bill Schumann. The stereo is on, and soon the music has set the mood and the beat that Gordon Parks is after. Through it he is able to slip into a different world, the quiet world of his mind.

When he is writing a poem, grasping for an image to express just exactly what he feels, he is almost always consciously looking, even though it may sometimes be only in his mind's eye, through the ground glass of a camera. That's how tightly the two arts of photography and poetry are tied in Gordon Parks' vision. He is, of course, first and foremost a photographer, one of the world's greatest. He has been sighting through cameras, framing what he sees there, capturing beauty and passion and drama and despair and hope, and creating mood and texture, mixing lights and shades and colors and learning to paint with his camera, ever since he was a very young man. And so it is not unusual that his poetry is an extension of his pictures.

This book is of the same world as *Gordon Parks: A Poet and His Camera*, which was published in 1968. It is, again, a combination of photographs and poems, a double statement—one pictorial, the other in words—but this time most of the words particularly relate to the photographs, and the photographs to the words. Both elements are to be read and looked at together or as separate parts. The elements are interwoven, they come from the same intelligence and imagination, they make a whole.

The poems come to Gordon Parks like little exploding strobe lights. He is staring out of his window; reading a book; he awakes in the morning; or he might be hard at shaving. Suddenly there is something there bothering him— a thought, a line. He goes to his desk. There, upon its paper-cluttered surface, a pair of glasses lies, a typewriter stands ready, a dictionary open; pens, pencils, pads are scattered along with pipes and a tobacco pouch. He gets whatever he can down right then. That evening he may study some of his color transparencies, those that, taken over the years, seem to tell him something about the character and content of his current thoughts and feelings.

Some of the best of his lifelong collection of photographs you will see in this book, romantic symbols mostly, haunting images that need no words to convey their poetic messages. A mother sheep feeding her lamb, the whole picture all wool looming out of black, nothing sharp, the essence of soft, kneeling, innocent creation at suckle. Stacked wheat, a pattern of stalks that glint back the sun and bring forth a strong feeling for simplicity and the bounty that can be wrought by man from the earth. A garden table and chairs in winter, blue-black-white, the dark of wrought iron making tracings against the white as the chairs idly surround a coffin of snow which only spring can

melt back to a glass table. The girl (who is she? we will never know) glimpsed through the window of a Paris restaurant. Road at dawn. Tree in winter. Noon slouch—a man in slouch cap, slouch coat, slouch shoulders, with slouch legs, enjoying the slouch-time of noon and his bread and his smoke. A nude—fresh and inviting as the linen texture of the photograph. A broken marble girl, lost in leaves. A wall filled with cracks and an old door. An explosion of pigeons. A night-note to a son from a worried father, left on the front hall table beneath a vase of overbloomed roses. The sea. A dove, lit by a sun that lighted Noah.

The music is playing. If the idea for the poem does not flow and enlarge upon itself easily, it is usually a false alarm and he drops it. But if it keeps coming back, being reaffirmed, and seems to blossom, then he knows it is right. The original idea is added to, fleshed out, then chipped away, edited down until the rhythm is just as he wants it to be, the words express with distilled economy.

An evening overlooking the river, a swallow of Cognac, the stereo soaring, the gentle-hard, rhythmic hands moving pen across paper, the music adjusting to the flow of the river, the poet becoming the freighter out there making its way toward the sea, becoming the tiny sailboat fighting the tidal current, becoming whatever his mind alights upon in its full range of experience and memory, becoming wheatstalk-friends in a long-ago field, becoming mourner, stranger, father, widow, lover, becoming Kent State blood, becoming the dove of peace, flying

> Relentlessly . . .
> Eyehaunted and weary . . .
> Over cracked villages and broken hills.
> Alongside the iron hawks it flew. . . .
> Belching wet-fire death. . . .
> Peace escapes soundless
> defeated
> Up through the jet-scream dark.

—PHILIP B. KUNHARDT, JR.

PEACE ESCAPES

Relentlessly it flew
Eyehaunted and weary
Into the boisterous smoke
Through moonblinking night
Over cracked villages and broken hills.
Alongside the iron hawks it flew
As they wing-dipped the acrid air
 firespitting and steelsneezing
Scalping green God-painted slopes.
And on it winged
Fluttering the frightened moonlight
Feathers torn and falling
 drifting
Down the endless dark
Over turret-nose beasts
Who roam the trembling fields
Belching wet-fire death.
The moon grows black,
Despairing of bleeding towns
Of cannons booming
 and
Ghosts of historic wars.
Peace escapes soundless
 defeated
Up through the jet-scream dark.

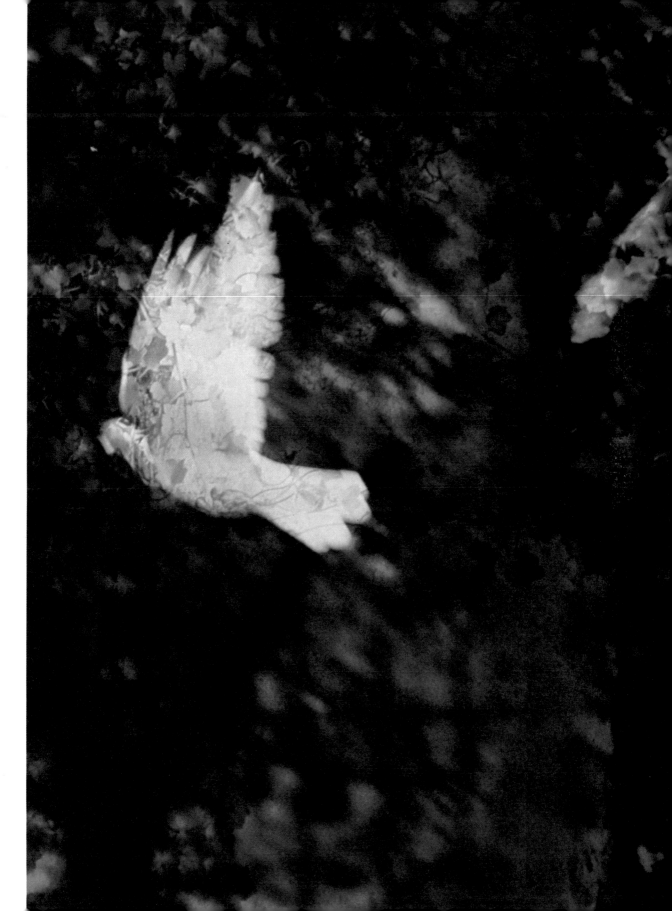

SOMETHING OF LIFE

Reflection
 is
 music
 and
 each
 song
 is
 something
 of
 life.
 How
 softly
 music
 flows
 against
 the
 watersides.

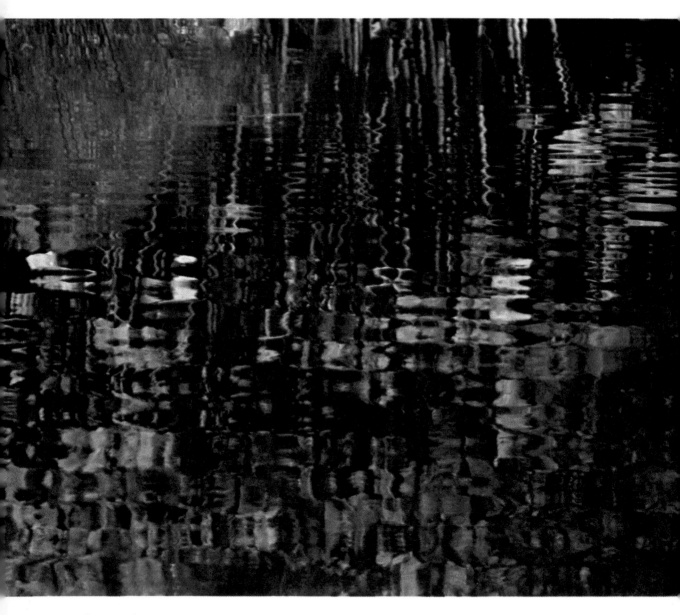

something of life

cups in an antique window

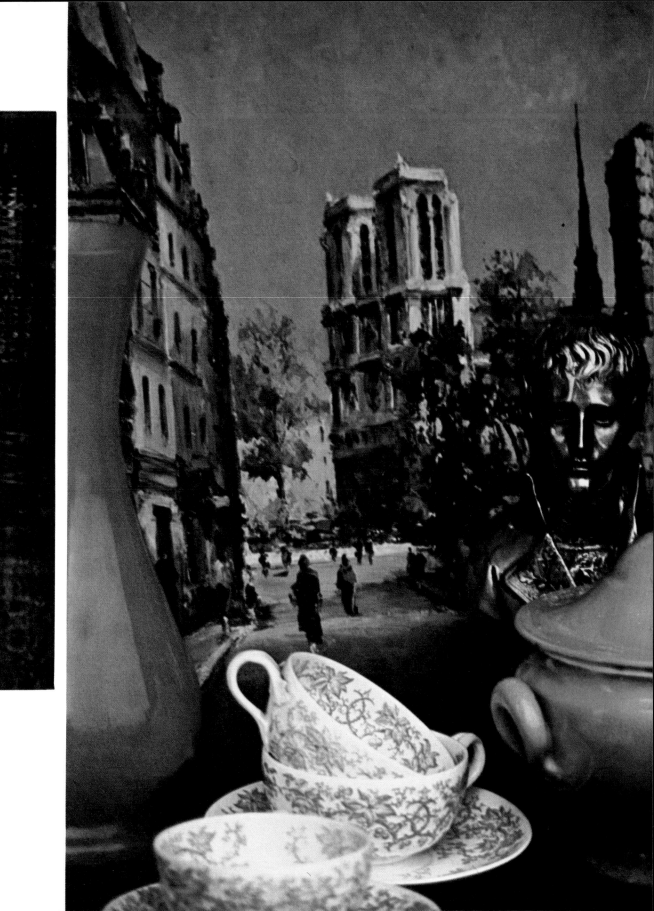

CUPS IN AN ANTIQUE WINDOW

A promise made was a promise kept
While beside some love bed
Their contents cooled.
And what vows have trembled
From whose lips above their rims
In some softly darkened room.
They heard the sighs of midnight
And laughter on sunny afternoons.
They felt the motion of age
 upon their handles.
They know the stillness of death
 above their bowls.

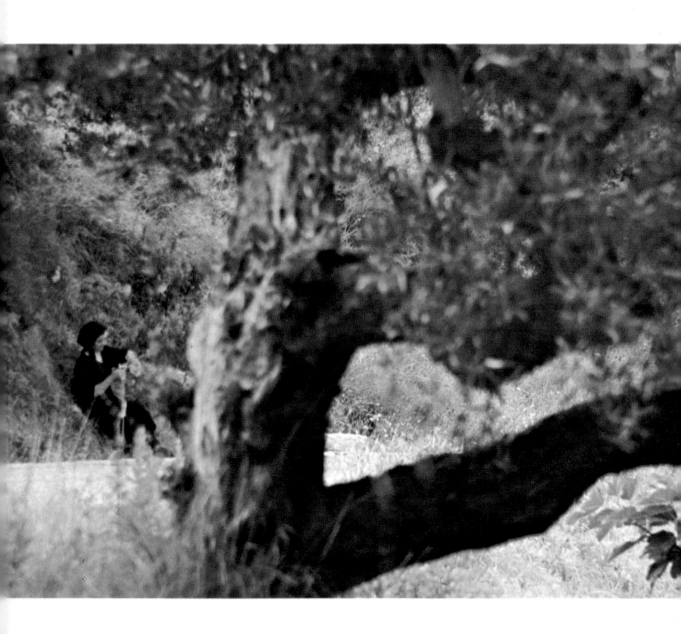

appraisal

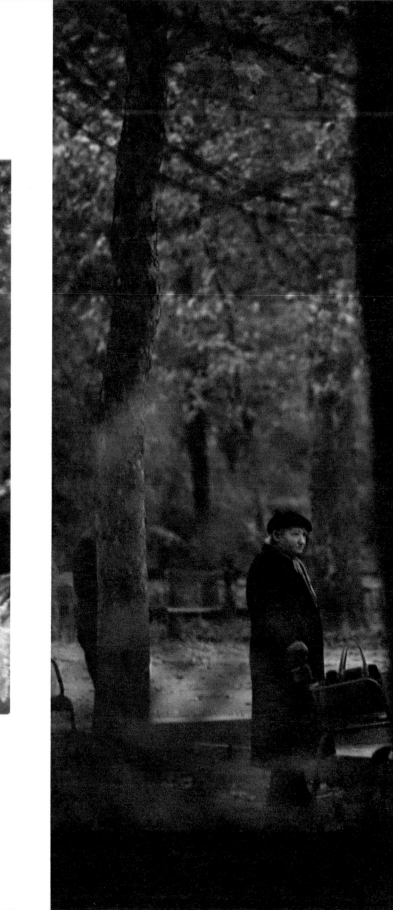

APPRAISAL

The years, thick with green oaks
 and gothic towers,
Had been her jewels.
There had been no deceptions to escape,
No memories to plague
 or
 unfinished promises to bear
No specters of a witless youth
And no silver lakes with fantasies to delude her.
The deep-banked river (she loved for its roar)
 had been sufficient.
She knew enough to know that
Things in themselves were not enough.
She preferred violets to orchids
And, keen to a need of honest love,
Took a band on her finger instead of pearls on her neck.
She was one to be taken for what she was—
A woman possessed of common dreams and spacious pride.

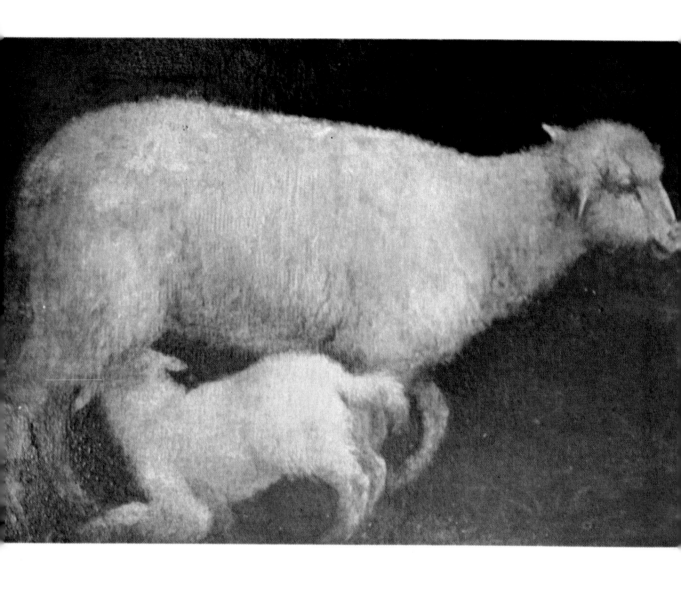

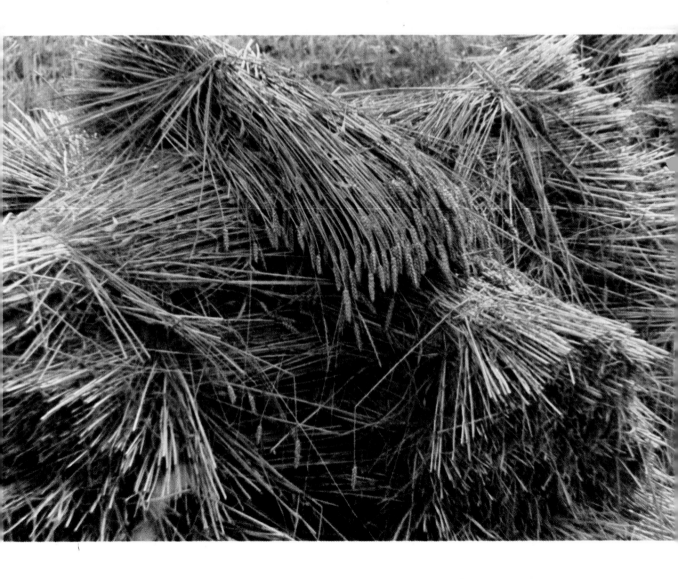

death of a wheat field

DEATH OF A WHEAT FIELD

While my father swilled the hogs
And hayed the sheep, they became my friends
Slipping through my fingers like watersand
Into the grainy deep of the oakbucket,
Gushing from my hand's leather bowls
Ignoring with me his tendergruff command:
Let those seeds be, boy—let them be.
Then to the rumpled field he went one day
 angry
Scattering my friends, burying them underfoot
 (I saw him with my own eyes)
And throwing them to the unfriendly wind.
With sorry heart I watched them die
Thousands of them my friends while
My father swilled and hayed.

But one morning in the sprouting spring
While my father toiled at other barnyard sins
Hundreds, then thousands, then millions of them
Peeped up slender from their graves
Smiling tender greenpointed smiles
 my friends undead again.
And from rain they drank, from the sun they fed
Growing a busy carpet-field for naked feet to play.
Three four five feet tall they grew while
My father wasn't watching.

Then one tragic dawn he caught them
 swaying there
Laughing at him in the unfriendly wind.
To the tool shed he went and honed his wicked scythe.
Out then to murder them right before my eyes
Without words, bundling them,
 whacking off their heads
Leaving their thin bones for suns to burn.
A fitting funeral I had for them
Pyre-stacked there for sacred rites
 beneath the pagan fire.
And God sent mosquitoes by billions for a choir to sing.
I heard them with my own ears
As my father swilled and hayed.

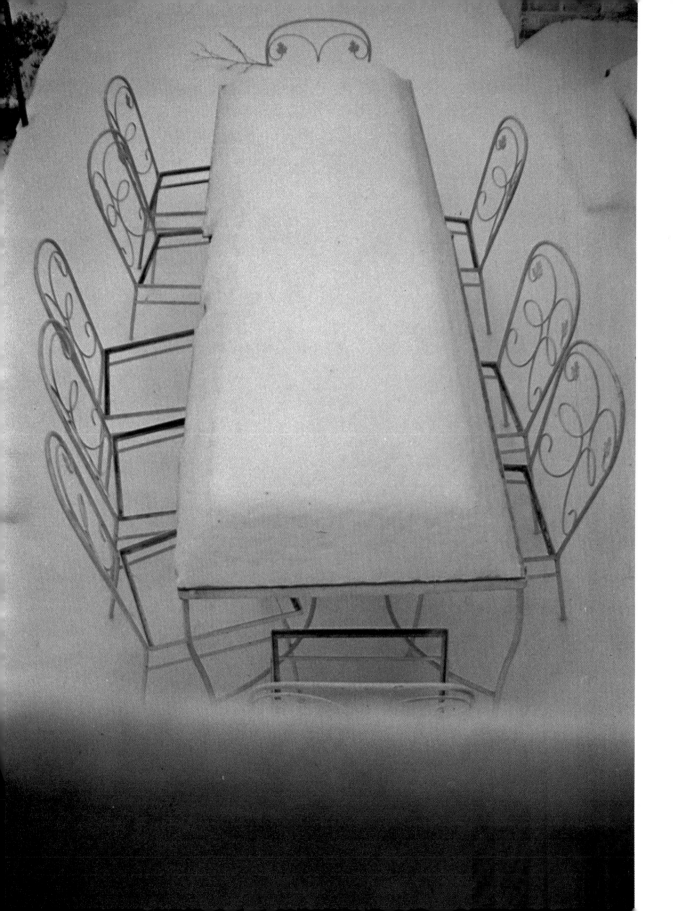

PERISHED SUMMER

Often, near the end of summer
She sat across from me,
Smiling in peculiar silence.
In months between it grieves
 me that
I came to know her name,
Her mannerisms, the delicate fragrance
But never the uncharted course
She took upon her lonely voyage.
Only a memory of her hangs here
In this noiseless winter,
 a memory to wander
To search each aimless direction
 she might have taken.

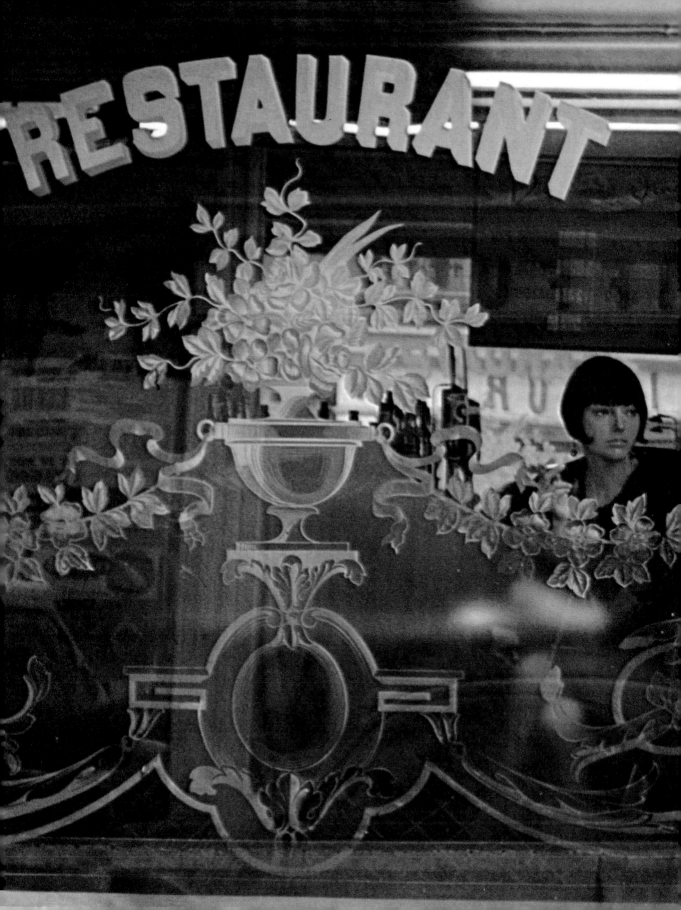

SPEAK SOFTLY YOURSELF TO ME

Woman in your birthly trappings
Speak softly yourself to me.
You virgin,
On your defiant bed
Breast pledging
 to
Some star-hushed night.
And you,
Uncloistered nun
Kneeling in nakedness
To your nobler love
Speak to me of innocence.
Night woman
 deep-joyed
In your imprudent trade
Voice your pain to me.
And you, dear woman,
Professing the single heart
Tell softly yourself to me
 of
Wedding noise and
Sleepless beds
Purged vows and love-breached nights
With fallen lovers damning the sunken moons.

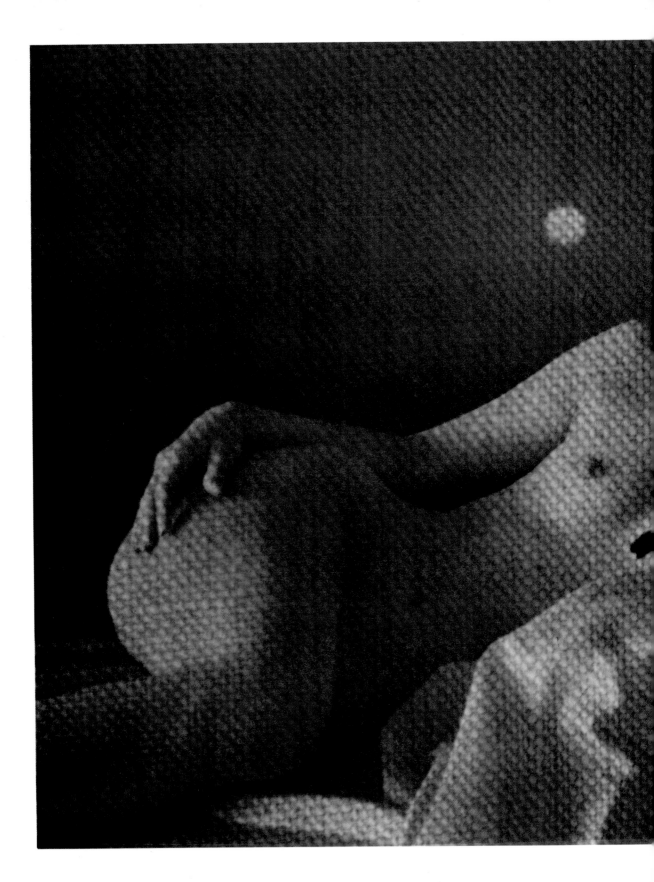

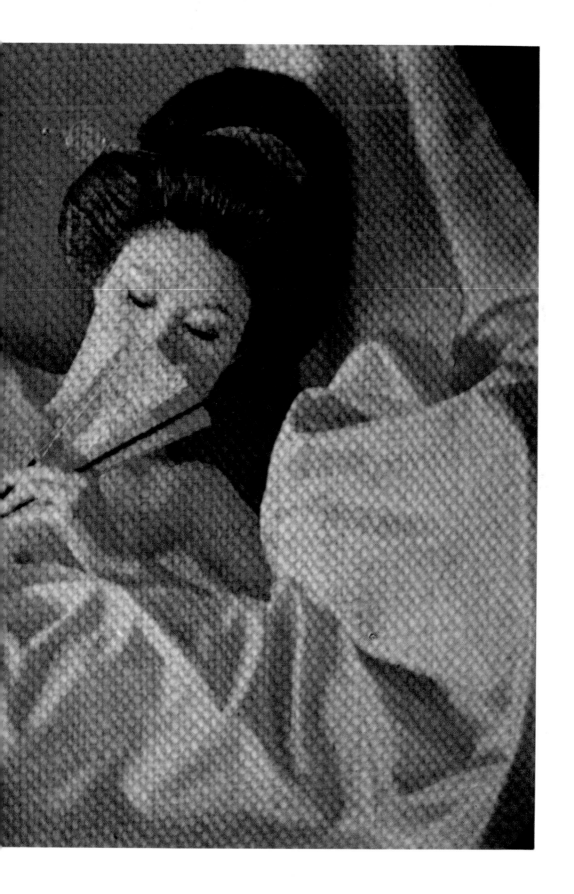

DILEMMA HE

She might pass for my father's wife—
A shame I never got to know her
But twenty years from my crib she's gone
 and to another love
Leaving only bridepictures to remember.
Don't be a fool, old boy.
It could, yet it couldn't be.

It's the wine— the magic wine.

DILEMMA SHE

Perhaps the wintersight
Deceives me, but the
Eyebluehairblacknosesharp
 look
Speaks the twentyyear love behind me.
There was this child (my son)
Surely the cognac
Played my glance a trick
But that chinupshoulderwidestronghead
 look
Nettles back wounded hours.

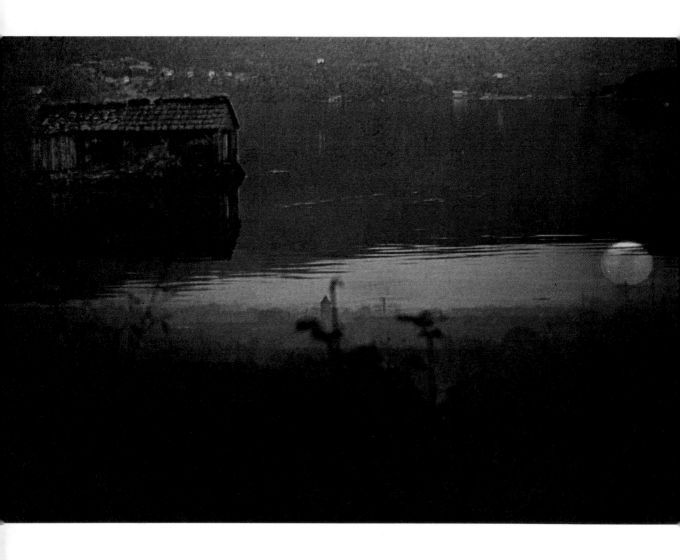

thespians don't die

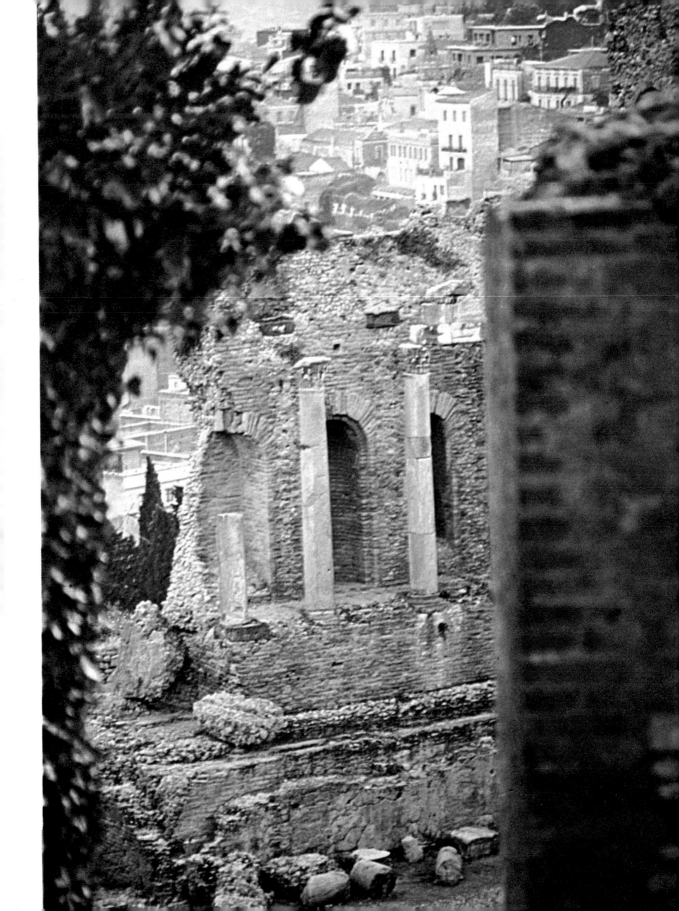

THESPIANS DON'T DIE

Time cannot murder them.
Here, in laced legs
In fluttering capes
Their agesucked voices
Summon Hellenic ghosts
Over and over to
These time-swept ruins
To lay Caesar dead again
Of dagger wounds.
With jaws hung loose
They praise Marc Antony
 and Lepidus
In the historic dust
Of their airless tombs.
Their hearts unbuttoned
To the Etruscan dark,
Their souls drunk
With Empire wine, they
Harangue the murderous
 deeds
Of Claudius and Caligula.
And time over time
Nero burns the Empire down,
Until finally they sing
Homage to Augustus. No,
Time cannot murder thespians.
They refuse to be finished
During the death of suns.

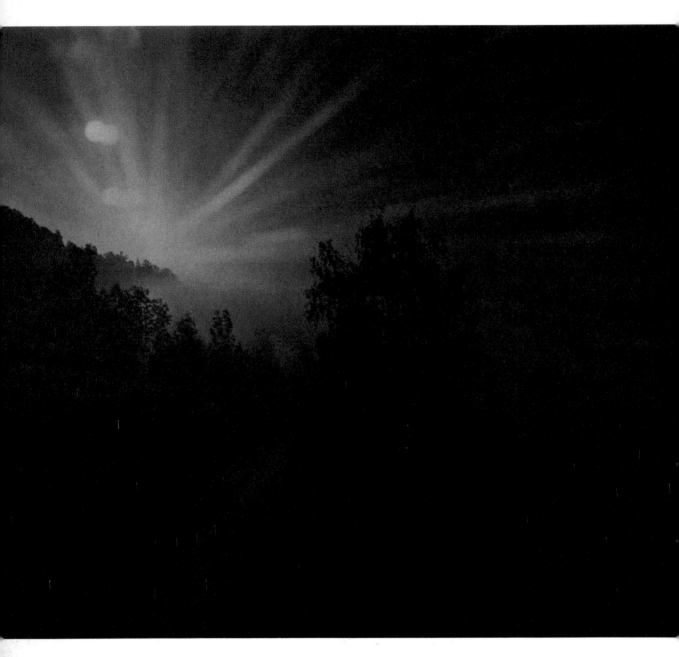

homeward stranger

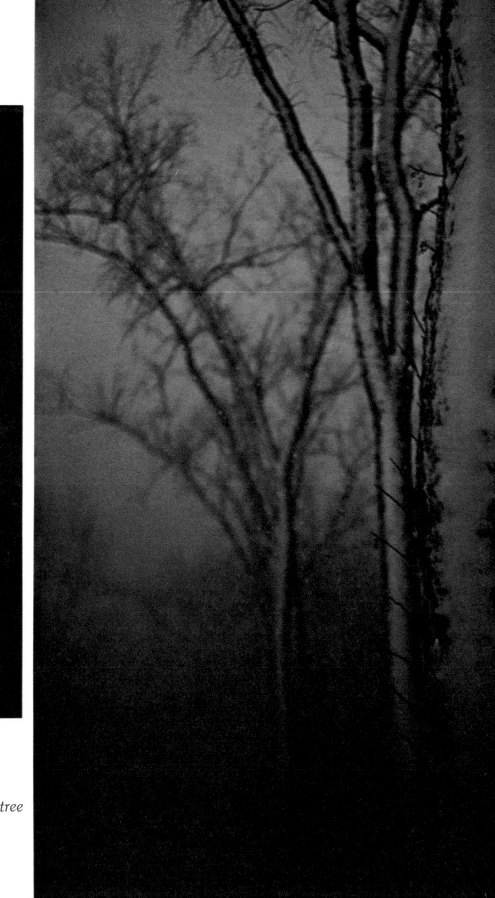

winter tree

HOMEWARD STRANGER

This morning slipping in now
Over dew-wet bulging hills
Under the speechless sky,
In my woodquiet house
In this leafpainted forest
Invaded by oak and maple,
Squirrel, fox, wolf and deer
With a beggar's violent hunger,
By restless, callow jays
In their wheatstraw nests
Princely owl and startled sparrow
Coated with babybreath mist
Shrouding God-tilted plains,
Firs brushing the heaven, trout
Leaping the fog-gray brook running
Far from the noisecracked towns I fled
Where collarwhite bears claw
And nighttime girls watched and
Waited in cathedraled places
For me to quench their thirsts.
Homeward I come supper-hungry
Reclaiming the mist-made dusk
Awaiting the star-reigned night
To sleep me and inhale my peace.

WINTER TREE

The winter tree
Summoned the boy
Each snowfall
To watch him
Inch above
The whiteness,
Measured his deeds
Against his growing.
 Then
One December
The boy returned
Prune-wrinkled
To tap the tree awake
 with his cane.
The tree spoke:
Wisdom is absent
From your eyes.
You are what you were
When you left the womb—
 A child.

THE FUNERAL

After many snows I was home again.
Time had whittled down to mere hills
The great mountains of my childhood.
Raging rivers I once swam trickled now
 like gentle streams.
And the wide road curving on to China or
 Kansas City or perhaps Calcutta,
Had withered to a crooked path of dust
Ending abruptly at the county burying ground.
Only the giant who was my father
 remained the same.
A hundred strong men strained beneath his coffin
When they bore him to his grave.

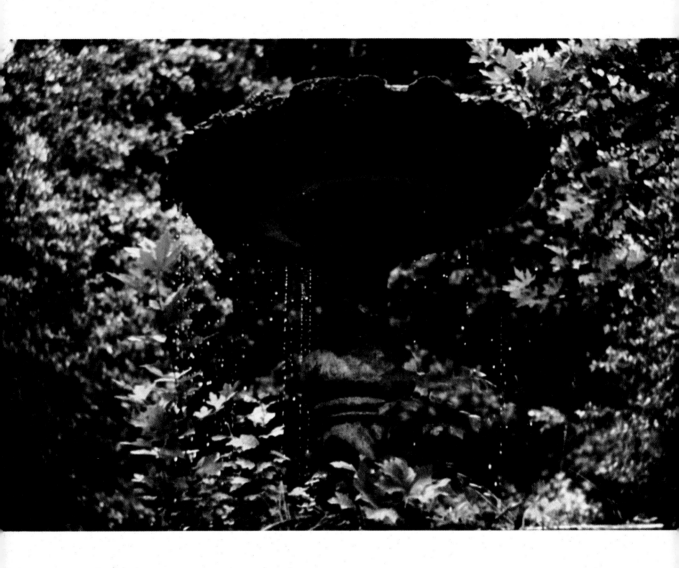

here at this fountainhead

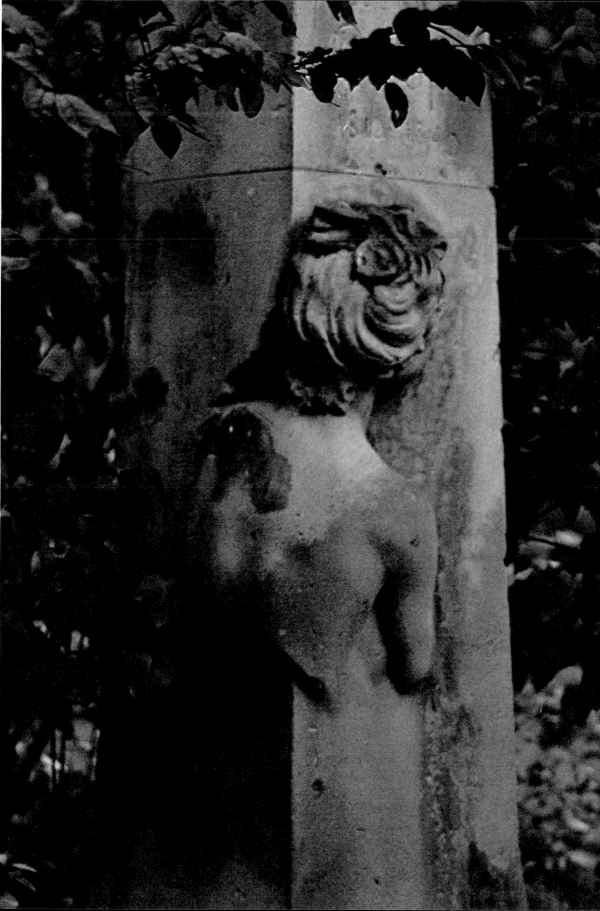

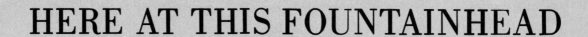

HERE AT THIS FOUNTAINHEAD

A sanctuary
Where mornings
Used to grow
 Where
Hearts pulsed
And stars wept
While full moons
Consumed narrow loves
And winter piled
Its noiseless snow.
A plot of silence
Ancient and green
Black as sorrow
Exceptional as truth
 Where
Virgins fell and
Men were made
On Venus thighs,
A place now condemned
To involuntary exile.

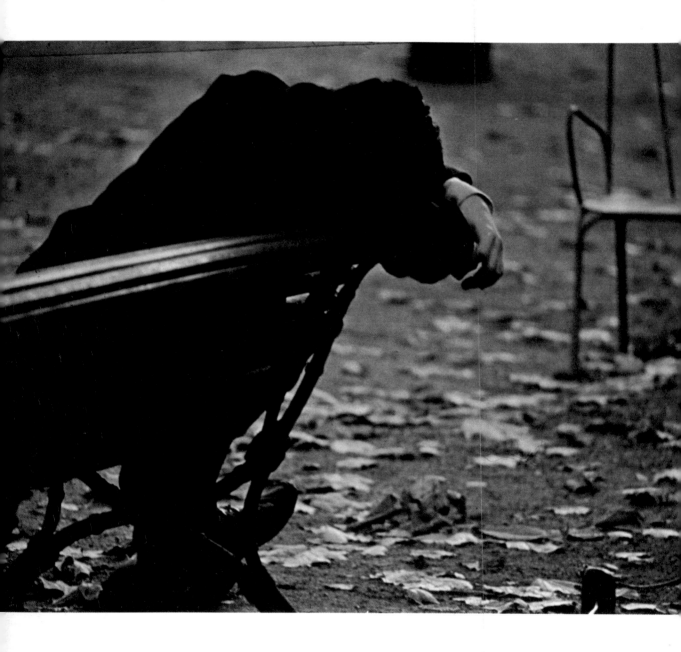

a once-pleasured house

A ONCE-PLEASURED HOUSE

It was duly commissioned and
 someone
Laid stone upon the stone
Before covering it with plaster,
How far back is for the guesser.
What took place in its time untold
Lies in ghosts of wine-wet nights
 that sing of
Pagan times few gods would dare to honor.
They sing on in haunted beds of
 relinquished virtue
That rust in rooms of carnal dust.
No guests are expected here tonight
And conjecture is the offering
 with no conclusions drawn
As to where the cause must lie.

The place has come to an end—
 It dies unexplained.

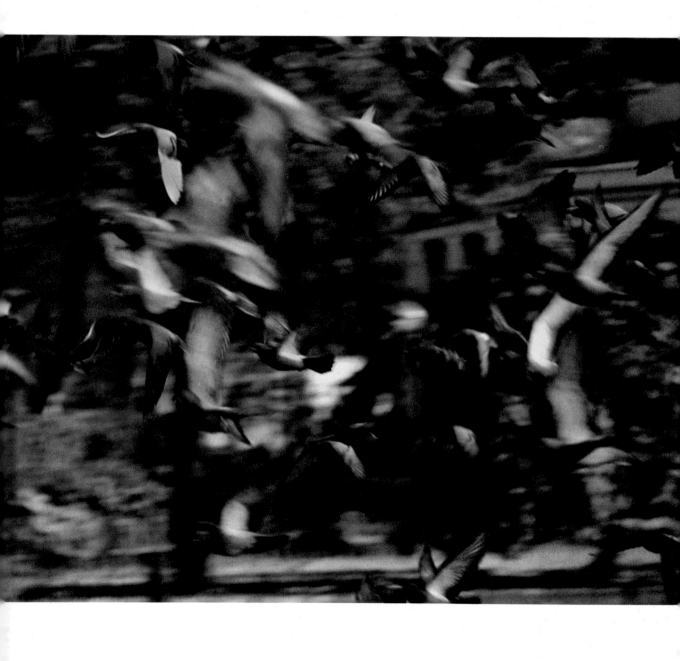

adolescence

ADOLESCENCE

Somewhere along the incalculable route
 to sixteen
I prostrated myself to it
To its heartbruising love
Half-lies, hazardous dreams
 and
Treasonable wit.
I charged it with profuse doubt
Remarkable arrogance
And a runaway tongue
To shield a naked shyness.
I conjured myths
 wild as swallows,
Desires unstruck with reason
And filled unfillable promises,
Kept well all well-known secrets
 and
Dazzled mirrors with my confusion.
In its pain-bred name
I was rapturously unhappy.

MARTYRDOM AT KENT STATE

. . . In that brief volley, four young
people were killed. Ten students
were wounded, three seriously.

And how could you hear
My voice grown hoarse
In praise of love flowers wilting
In some strung-out night?
When even in cow fields
I sang a million-voiced war
 against your war
You didn't hear my singing—
Not through the din of stiff-winged hawks
Laying hostile eggs on foreign nests
Nor in the precise carbine stutter;
 not through
The pow shooooming of rockets launched
To fire the village shelter-straw
And mix the mudswamp bone and flesh.

I come now marching in, sitting in
 loving in
Putting my body talk on you
So you might feel what you couldn't hear.
I plant my black flag of pot leaf
 and blood-color star.

And I tell you like it is—
 Up the establishment!
To die without hope
With limbs sprouting swords
That I may fall upon,
To die a foolish suicide
 I refuse.
I spurn the posthumous medals
Your generals pin on post-mortem chests.
Pigs!
Off the campus—I don't want your war!
"Shoutyourslogans justkeepitpeaceful"
Off the bull—off your pigs—
I don't want your war!
"Whenactionishotkeeptherhetoriccool
 . . . justgivepeaceachance"
Peace has fled at full gallop.
You have challenged it to die.
So rocks for your rifles
And bricks for your gas.
I hoist the flag and let my body talk.
 Charge!
Their guns are filled with blanks.
And I am falling I am struck
 My God
A red river pours from my head
Beneath my book of history words,
To course the campus green . . .
"Whendissentturnstoviolenceitinvitestragedy.
Off my grief off my corpse.

A Man without love
 is a
 day without hope
 is a
 song without music
 is a
 poem without words.

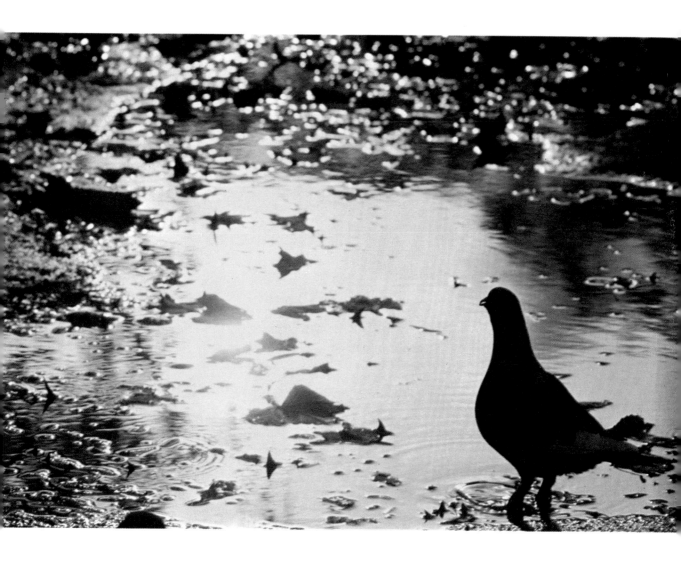

CHIMNEY POTS

Always, as evening deepens
I watch them swimming, eel-gray,
Through the window
Of an old rheumatic bistro
On the rue du Bac,
The boneless black necks
Organized against the sky.
Smokeless now
Their throats breathe undead air
From tombs below
Where men dwell
Banished to loveproof worlds
Where nothing much begins
Except the end.
And their hollow throats exhale
The hurt of scissored voices
Beneath the coral roofs
Voices sharpened
By wounded thoughts—
Thoughts nurtured
In the corpse-cold air.

this house floating

THIS HOUSE FLOATING

This house floating there
In the moonstalked sea
Sloshing in the larger reality
Of my wrinkled mind, tangling
And untangling my frigid thought
Governing the voice I speak—
But fail to hear,
Bearing me high cost for
The thorny peace it brings,
Wrought with love and
Burnished with moondown fear
And wedded to spleenful mornings
Where flower tongues once spoke
In a lovebed now gone sour.
I watch now from the noiseless deep
Not thinking, trying not to remember
The quartered nights and endless days.
It is my sorrow there
 glistening the water.
I am the great black shade
Glimmering the dancing eaves.
This house, twisting there
In the agony of a moonstalked sea
Can no longer shelter me.

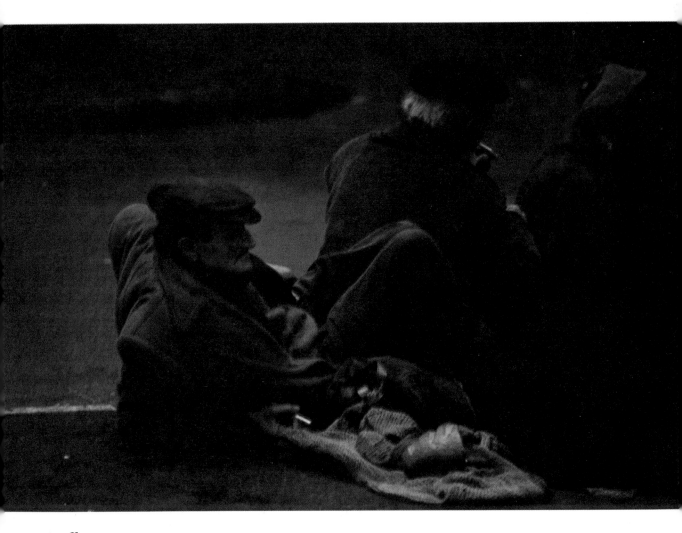

in all men

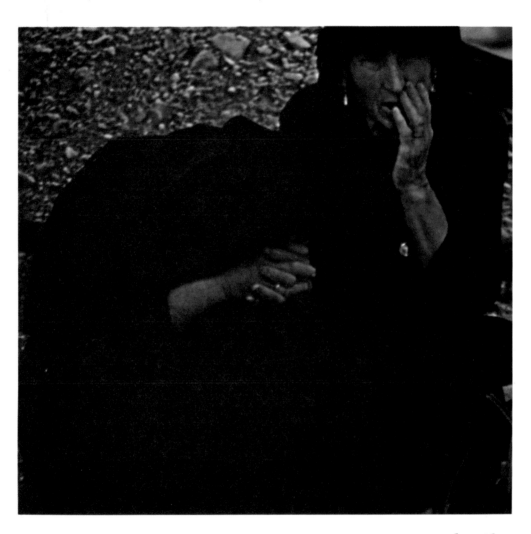

the widow

IN ALL MEN

In all men
Love or hate
Is inevitable.
Young men,
With fewer
Loves conceived,
With fewer
Hates defined,
Make more
Imprudent choices.
Old men,
With little time
Left to waste
Seldom choose—
Knowing that both,
Love and hate,
Are filled with pain.

THE WIDOW

It had been different in the beginning
Seeing in those she bore for him
Something she might have become.
And her reasoning was her wisdom:
To love when it was only she who loved
To give when only it was she who gave.
 And she dreamed
Dreams to bury in smoke thickened by ages
 of cannon fire.
Smoke and fire—it choked him dead.
She has tears now only for the salty sea
Where his blood with thousands reddens the brine.
She sits with no road left to travel
 refusing to quarrel with fate
And accusing her dreams of lies.

The young ones have fled—
Perhaps theirs was the greater wisdom.

request

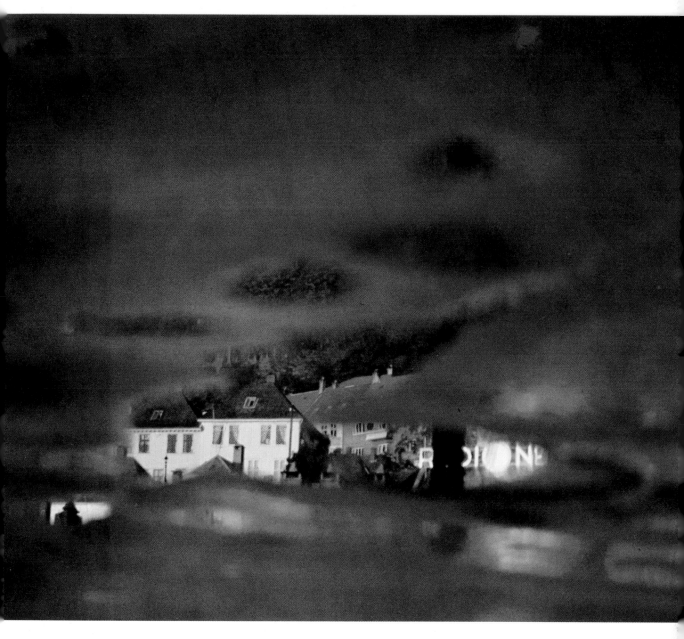

houses by the sea

REQUEST

Reach gently down
And stroke December's brow
Shiver me awake
With your icy fingers
And let me escape
The womanless dark
 to drink
From breasts of spring,
April's milk just once again.
Reach gently in
And grasp my outraged heart.
Break the frost
From around the veins—
Then let it exult
In one more love
Before the final night begins.

HOUSES BY THE SEA

I last saw them smiling
Seashaken and shimmering
In the spring-eye morning
Through mirrors of leftover rain
On wharves where fishwidows
Mourn watersilent fathers
No longer warming their beds.
Time blessed, they exult against
The circling seasons,
 their faces
Skywashed, windscrubbed
And dried by salmon suns.
Braided now in my memory
The voices of morning
Grumbling against clapboard,
Mountain mists bowing
To slake the noonburn
On cobbled rooftops,
Moonlight, rainwashed and bending
Against the seaward windows.
A heaven descended—
To an unjudged world.

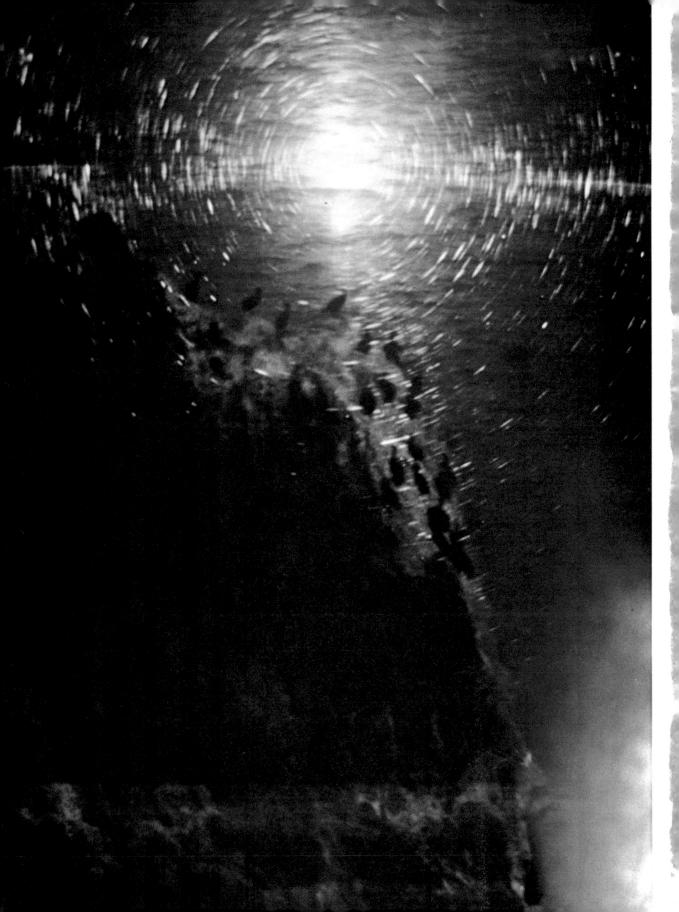